The
Flower
Painter's
POCKET PALETTE
BOOK 2

Practical visual advice on
how to paint flowers

Adelene Fletcher

CHARTWELL
BOOKS, INC.

THE FLOWER COLORS

A QUARTO BOOK

First published
in the USA
by Chartwell Books
A Division of
Book Sales, Inc.
114 Northfield Avenue
Edison
New Jersey 08837

ISBN 0-7858-1173-7

QUAR.FPPP

Conceived, designed,
and produced by
Quarto Publishing plc
6 Blundell Street
London
N7 9BH

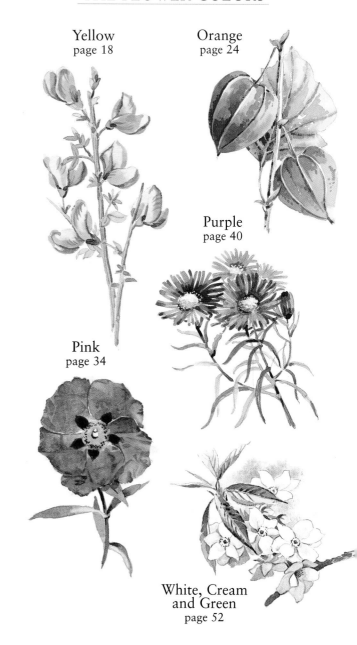

CONTENTS

Red
page 28

Blue
page 46

Berries
page 58

Leaves
page 60

4

HOW TO USE THIS BOOK

THE AIM OF THIS book is to show how to paint a vast collection of flowers, leaves, and berries, employing a wide variety of techniques. A color chart and paint permanence ratings introduce the various colors, hues and tones typically used by flower painters. Various techniques by which watercolor paint can be manipulated to create impressive flower portraits are then described. The flowers are categorized into a series of basic shapes, with a description of each flower type, and drawings examining the perspective, and the patterns of light and shadow comprising the three-dimensional form. Step-by-step demonstrations follow, illustrating the painting techniques and analyzing the color mixes required to produce a spectrum of flower shades.

This color code indicates a selection of flowers in a particular color range, and suggests which paint mixes to use in order to achieve a wide variety of tones and color variations.

Flowers are identified by their common names, or Latin names if these are better known, and at least one example of each basic flower shape is shown.

Each flower is painted as a sequence of one or two steps, followed by a final painting. Captions describe the colors used, the color mixes required, and the techniques involved.

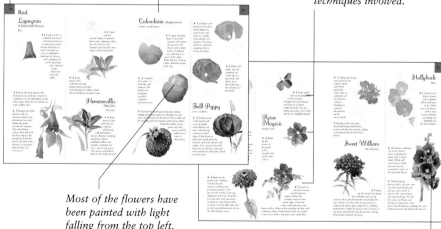

Most of the flowers have been painted with light falling from the top left. Note your light source, and build the flower shape accordingly.

Specific direction is given throughout the book on how to paint light-reflecting areas and dense shadows.

COLORS

Lemon yellow***O | Indian yellow**Tr | Cadmium orange***O | Bright red***O St | Alizarin crimson**T | Permanent rose***Tr St

Cobalt violet ****Tr | Dioxazine violet ***Tr St | Cobalt blue ****Tr | French***Tr ultramarine | Phthalo blue ***Tr St | Sap green **Tr St

Cadmium yellow***O | Naples yellow ***O | Quinacridone gold***Tr St | Green gold ***Tr | Cadmium red***O | Brown madder **Tr St

Rose doré ***Tr St | Permanent *** magenta Tr St | Permanent mauve***Tr | Cerulean blue****O | Indigo ***O St | Cobalt green ****O

Phthalo green ***Tr St | Raw sienna ****Tr | Burnt sienna ****Tr | Raw umber ****Tr | Burnt umber ****O | Olive green **Tr

CODES

****	Extremely permanent	O Semi-opaque/opaque
***	Permanent	Tr Semi-transparent/transparent
**	Moderately durable	St Staining color
*	Fugitive color	

TECHNIQUES

WATERCOLOR LENDS ITSELF to many different techniques, and there are various tricks of the trade that are especially helpful to flower painters. Some of the most valuable techniques for flower painters produce textures and patterns without the use of a paintbrush.

WASHES

Washes, which may cover a large or small area, are the starting point for most watercolor paintings. Washes need not be completely flat—they are often graded in tone or contain more than one color.

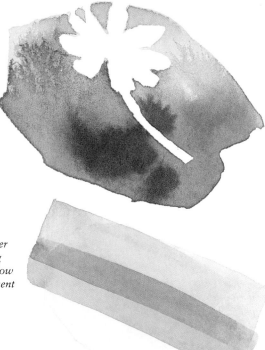

► **Variegated wash**
The shape was dampened, with the flower and the area outside the shape left as dry paper. A succession of colors were then dropped in, merging together but stopping where they met dry paper.

► **Glazing**
This is the term used for a wash laid over other dry colors, and is a way of mixing colors on the surface. Here a lemon yellow wash was laid first, followed by permanent rose and then phthalo blue.

AMENDING COLORS

A "bitty" painting, where the colors are not working together properly, can be unified with an overall glaze. The same method can be used to subdue over-bright colors or to enliven dull ones.

▶ **Unifying colors**
The pink and yellow were too distinct from one another, but a glaze of permanent rose laid on top has brought them together.

◀ **Subduing colors**
The background colors needed to be cooler in color to push them back in space, so a thin glaze of phthalo blue was laid over them.

▶ **Enlivening colors**
The leaves were painted in two tones of a neutral green, which was then overlaid with phthalo green to give them more sparkle. Phthalo green, phthalo blue and alizarin crimson are staining colors, which are especially useful in this context.

CREATING SOFT EDGES

Hard edges form naturally where a watercolor wash meets dry paper, but these edges can easily be softened with a damp brush. Avoid using too much water, as this can cause backruns. Soft edges and color blends can also be achieved by the use of controlled wet-in-wet methods.

▼ **Combined methods**
A damp brush was stroked along the top of the petals to soften the edge and thus give depth to the flower. In the center, darker, dryer color was added to a still-damp first wash.

▲ **Blending colors**
With the paper dry, the colors were laid on so that they just touched one another, blending together with no hard edges.

TWO-COLOR BRUSHWORK

Color and tone gradations are achievable in one brushstroke. A Chinese brush is best, but a medium-sized round brush can also be used.

▶ **Painting a bi-colored shape**
A Chinese brush was filled with yellow. The tip was then dried, and the brush held horizontally before being dipped in red. To apply the colors, the brush was held at a slant, pressed down and turned from the tip to the body of the brush, releasing each color in turn.

AVOIDING COLOR RUNS

Leaving white lines between petals or leaves allows you to paint each one without the colors running into one another. This saves time, as you need not wait for an area to dry before working on the next.

◀ **White lines**
The flowers were painted from front to back, with white lines left around some of the petals to separate the colors. Avoid leaving too many white lines, as this can look mechanical.

NEGATIVE SHAPES

It is vital to plan a watercolor painting in such a way that you retain, or emphasize, the white and pale shapes. This is done by painting the negative background shapes around and between petals or leaves.

▶ **White highlights**
A relatively strong blue wash was painted around the light-catching lower petals, followed by two yellow washes on the back petals. For further emphasis, dark shadows were added in the center.

SCRATCHING OUT

This technique, also known as *sgraffito*, is used for small linear highlights and details. The commonest method is to use a sharp point or knife to scratch into dry paint, revealing white, but there are many variations, such as the one shown below.

◀ **Two-color effects**
Here a top layer of still-damp paint has been scratched through with the edge of a palette knife. Timing is important; if the paint is too wet or too dry the method may not work. In the centers of the flowers, a sharp blade was used to scratch out tiny highlights in dry paint.

IMPRESSING

Pressing a material such as plastic wrap (cling film) or kitchen paper into wet paint is a good way of suggesting the papery texture of some flowers. The method is slightly unpredictable, so practice it before using it in a painting.

▶ **Plastic wrap (cling film)**
A wash of fairly strong color was laid over the whole flower head, and with the paint still wet, crumpled plastic wrap was laid over it and left to dry. For a softer effect, the wrap can be removed before the paint is completely dry.

FLOWER SHAPES

BELL

Campanula

◀ **2** *For this frontal view, start by marking lines radiating from the center out to the petal tips.*

▲ **1** *For this side view, begin with a central line from the stem right down the flower center, then draw in two ellipses at top and bottom to give the basic cone shape and curvature of the petal tips.*

▲ **3** *From this angle, the petal tips form an ellipse, with the central line of the stem running through the middle.*

These flowers are strong shapes based on a rounded cone, and you will see quite strong tonal variations caused by the play of light. Depending on the light source, either the outer or inner part of the cone will be in shadow. Many bell-shaped flowers droop, bending over at the tops of the stems, but others are upright or grow out almost at right angles to the stem, either clustering around a central point or spaced at intervals down it. Pay special attention to the relationship of the flowers and stems.

TRUMPETS

▼ **2** *For the back view, pay special attention to the ellipse formed by the petal tips as well as marking in the central stem line.*

▼ **1** *Start by drawing a central line connecting stem to flower, then draw in two ellipses at each end of the cone, centered on this line. The petals forming the disc shape all spring from the center of the cone base.*

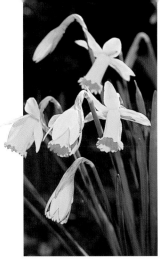

Daffodil

▼ **3** *The side view is the simplest, but note the length-to-width proportions of the cone and petals.*

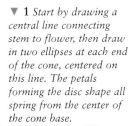

Many trumpet-shaped flowers start with a tubular shape, with petals flaring outward toward the tip to form the trumpet, but daffodils are more complex, being a combination of two basic shapes. The central cone is surrounded by a larger circle of radiating petals, which will become an ellipse when seen from an angle.

LIPPED AND BEARDED

Cytisus

▼ **1** *This face-on view shows the basic construction—three tubes under a fan-shaped upper petal.*

▲ **2** *The side view shows how the petals lead down into the collar of the calyx and then into the stem, following a central line.*

▲ **3** *As the flower turns away from you, it is important to observe the effects of perspective, and to emphasize the structure with careful shading.*

All flowers are symmetrical, with their structures governed by a few basic rules. The majority of flowers are called "regular," but lipped and bearded flowers are called "irregular," because they are unusual in being divided into two corresponding equal parts along a middle line running from top to bottom.

CUP AND BOWL

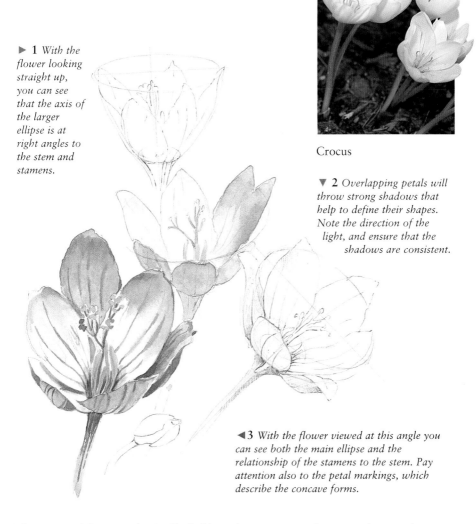

► **1** *With the flower looking straight up, you can see that the axis of the larger ellipse is at right angles to the stem and stamens.*

Crocus

▼ **2** *Overlapping petals will throw strong shadows that help to define their shapes. Note the direction of the light, and ensure that the shadows are consistent.*

◄ **3** *With the flower viewed at this angle you can see both the main ellipse and the relationship of the stamens to the stem. Pay attention also to the petal markings, which describe the concave forms.*

This type of flower is basically half a sphere, varying from a tight cup shape to a wider, more open bowl. Just like a cup, the flower will form ellipses at the top and bottom. It is important to maintain the sense of volume, so always identify the basic structure before drawing in the individual petals.

RAYS AND POMPOMS

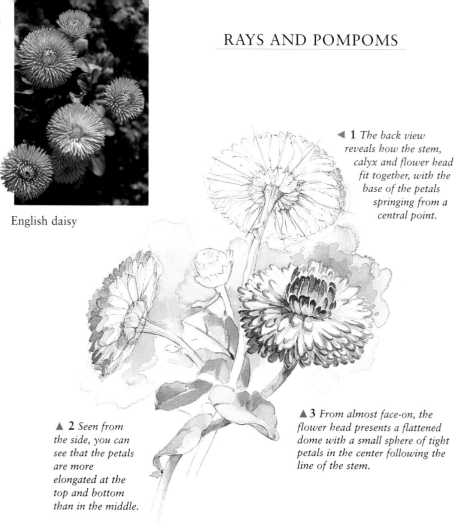

English daisy

◀ **1** *The back view reveals how the stem, calyx and flower head fit together, with the base of the petals springing from a central point.*

▲ **2** *Seen from the side, you can see that the petals are more elongated at the top and bottom than in the middle.*

▲ **3** *From almost face-on, the flower head presents a flattened dome with a small sphere of tight petals in the center following the line of the stem.*

These flowers are based on a circle, with petals radiating outward like spokes on a wheel. The ray shape is a simple disc, seen as an ellipse when viewed at an angle, but pompoms are more varied, with a mass of small petals that spiral from a tight center to form a dome, or even in some cases a globe shape.

SIMPLE STAR

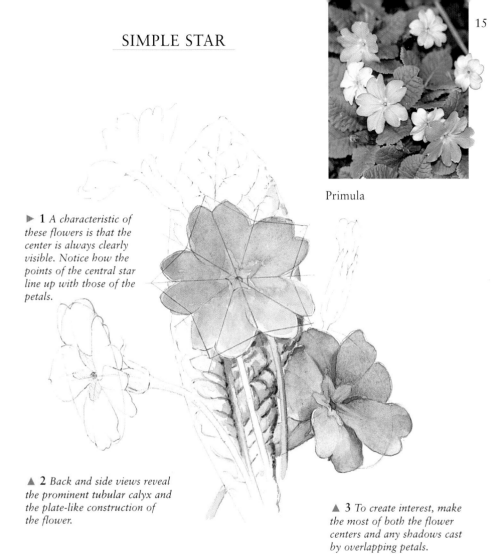

Primula

▶ **1** *A characteristic of these flowers is that the center is always clearly visible. Notice how the points of the central star line up with those of the petals.*

▲ **2** *Back and side views reveal the prominent tubular calyx and the plate-like construction of the flower.*

▲ **3** *To create interest, make the most of both the flower centers and any shadows cast by overlapping petals.*

When viewed straight on, these simple flowers can be seen as a flat circle with the petals—usually five—radiating out from the center and arranged geometrically around the perimeter. They are grouped in different ways on the stem, some being single blossoms and others clusters.

MULTIHEADED

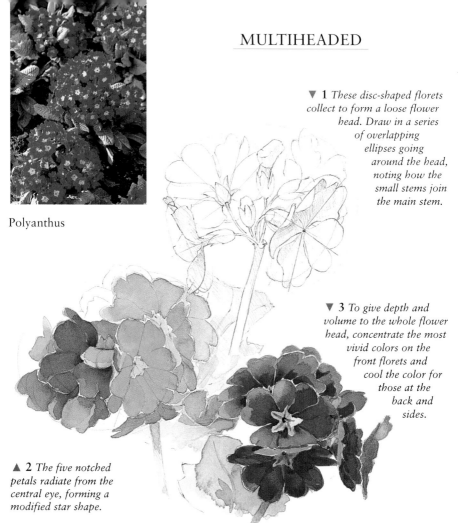

Polyanthus

▼ **1** *These disc-shaped florets collect to form a loose flower head. Draw in a series of overlapping ellipses going around the head, noting how the small stems join the main stem.*

▼ **3** *To give depth and volume to the whole flower head, concentrate the most vivid colors on the front florets and cool the color for those at the back and sides.*

▲ **2** *The five notched petals radiate from the central eye, forming a modified star shape.*

These flowers are among the trickiest to draw because the whole is made up of many parts. Always start with the overall shape, which may be a sphere, a spike, a cone or a tight ball shape, and then analyze the basic shape of the florets and the structure of the flower head. Often the florets are arranged in an umbel, each borne on a little stem radiating from one point. Imagine you can see through them and follow the line around the back and sides, constructing as you draw.

SPIKES

▶ **1** *The florets encircle the stem at set spaces down its length, so begin by drawing a series of ellipses upward from the bottom of the cylinder, making them shallower as they reach the top.*

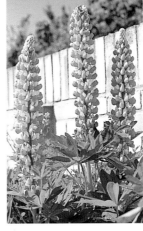

Lupin

▶ **2** *To convey the roundness of the spike, look for light and shade on the overall shape and then analyze the shapes of the petals. Avoid making them too regular in shape and size.*

◀ **3** *Often there is upper light on some of the pea-like petals, with the lower pouch in shadow. If you wish, you can simplify the image by picking out just a few foreground florets to treat in detail.*

This type of flower is a simple pointed cylinder, with many small florets attached to the central stem. To draw the main shape, half-close your eyes so that you are not distracted by detail; the main mass and the colors are the most important aspects of these flowers, and you may only need to pick out a few florets to treat in detail.

Yellow

▶ **1** *Make an outline drawing, then mix a wash of lemon yellow and Naples yellow. Lay evenly over the flowers. While still damp, lift out some color with a clean dry brush to highlight.*

Jonquil-Narcissus
TRUMPET

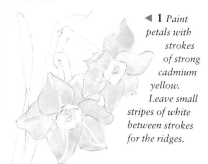

◀ **1** *Paint petals with strokes of strong cadmium yellow. Leave small stripes of white between strokes for the ridges.*

Datura
"Angel's Trumpets"

BELL

◀ **2** *Paint sap green on leaves. Before the paint dries, drop in lemon yellow on the tips. Let dry, then paint shadows on the right-hand flower with a mixture of raw sienna and cobalt blue.*

▶ **2** *Build up the petal forms using quinacridone gold and cadmium yellow. Wash cadmium orange into the small trumpet shapes.*

▶ **3** *Use the same shadow colors for the other flower, strengthening the mixture for the dark areas. For the leaves and cups, use sap green and olive green.*

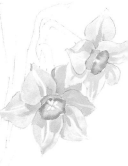

◀ **3** *Paint the sheath with raw umber. Use a mix of sap green and phthalo blue for the leaf and stems. Paint brown madder on the edges of the trumpets.*

Broom

LIPPED

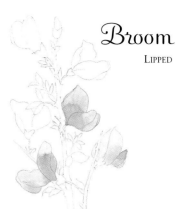

▲ **1** *Paint a wash of cadmium yellow over the flowers. Before it dries, lightly drop in Indian yellow at the base of each flower so that it blends in gently.*

2 *When dry, paint petal details using quinacridone gold. Paint stems and leaves with a mix of sap green and cadmium yellow.*

▶ **3** *Mix a touch of burnt sienna with quinacridone gold, and build up the flowers. Add a few lines to emphasize the forms of the petals. Paint vertical lines on the stems with a sap green and olive green mixture, using touches of this color to pick out details on the leaflets.*

▶ **1** *Paint each petal with a lemon yellow wash, and gently lift out highlights with a tissue. While the paint is still damp, drop strong cadmium yellow around the center of the flower and on the folded edges at the bottom and side.*

◀ **2** *Build up the petal shadows with a mix of cadmium yellow and cadmium orange. Wash leaves with sap green, and highlight using lemon yellow.*

Rose

"Canary Bird"

CUP AND BOWL

▶ **3** *Dot in the anthers with brown madder, using a paler mixture for those at the back. Emphasize the orange center with a dark sap green semi-circle at the front. To make the flower stand out, darken the leaves behind it with a sap green/olive green mix, and paint in a few veins with a fine brush.*

► **1** *Paint the clusters of long, narrow petals with crisp strokes of cadmium yellow, taking the brush out from the center of each flower. Darken some with quinacridone gold, weaving the brush in and out.*

◄ **1** *Flood each petal with lemon yellow. Before it dries, lift out highlights with a clean brush.*

◄ **2** *Paint the flower centers with dots and small dabs of burnt sienna, then wash in the branches with raw umber.*

Primrose

SIMPLE STAR

► **2** *Leave to dry before painting in shadow areas with a mixture of green-gold and quinacridone gold, immediately softening some areas with a damp brush.*

Witch Hazel

POMPOM

► **3** *To convey the feathery impression of the flowers, parts of the branches must be painted between the petals, then darkened in places with a mixture of raw and burnt umber. Add burnt umber to emphasize the centers.*

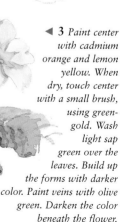

◄ **3** *Paint center with cadmium orange and lemon yellow. When dry, touch center with a small brush, using green-gold. Wash light sap green over the leaves. Build up the forms with darker color. Paint veins with olive green. Darken the color beneath the flower.*

◄ **1** *Draw the whole flower head initially as one shape, then lay a lemon yellow wash over it. Lift out highlights with a tissue.*

► **2** *Dot in the flower centers with quinacridone gold, lightening as they recede. Paint the leaves and stem cobalt green.*

Achillea

MULTIHEADED

◄ **3** *With a cobalt green and ultramarine mix, carefully paint a suggestion of foliage behind some of the florets. Use the same mixture to add definition to the stems.*

Mahonia

SPIKE

◄ **1** *Paint the spiky florets with a mixture of cadmium yellow and lemon yellow. Keep the edges broken and uneven.*

► **2** *When dry, paint quinacridone gold around the spikes' bells. Color leaflets behind the flower using a cobalt green and sap green mix.*

◄ **3** *Add some dark leaves behind the central spike, using a sap green and olive green mix. Paint the stem in burnt umber.*

SUNFLOWER GARDEN

Adelene Fletcher
(22 " x 18½")

THE BOLD SHAPES and vivid color of sunflowers make them an appealing subject for artists, and in this painting the artist has made the most of both shape and color. To enhance the yellows, she has brought in the complementary color, violet, thus setting up an opposition that enlivens the whole image.

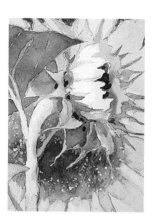

▶ *This bud is the focal point of the painting, and the way it overlaps the large flower head gives depth. The watercolor has been handled quite loosely while still being carefully controlled. Notice the variety in the treatment of the calyx spikes, with some painted darker than the background and others lighter.*

▼ *Here again, overlapping creates depth. The right-hand flower is in partial shadow, with colors ranging from lemon yellow through to deep quinacridone gold plus a touch of blue for the area in deepest shade. A touch of violet in the flower center continues the yellow/violet complementary color theme.*

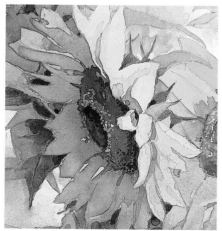

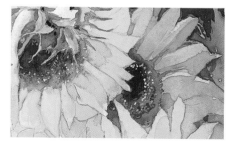

◀ *The flower center has been painted with the minimum of botanical detail so that it does not steal attention from the focal point. To create the shadow effect, the yellow of the petals has been glazed over with thin washes of violet.*

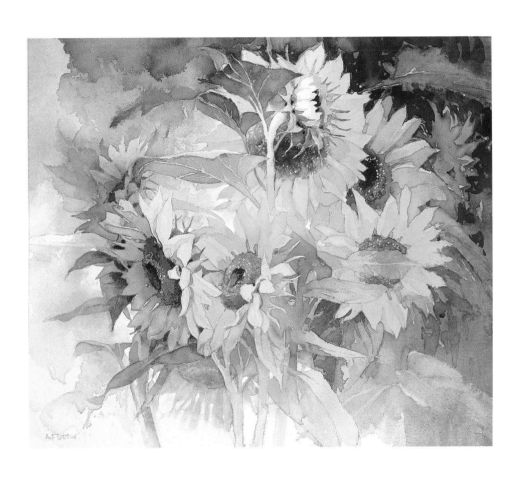

Orange

◀ **1** *Keeping the paint wet, paint an Indian yellow wash at the top, deepening it to cadmium orange at the bottom. Leave some white lines for the ridges. Add cadmium red for the shaded side.*

Campsis
TRUMPET

▶ **1** *Paint the trumpet and petals with full-strength Indian yellow, then mix in some cadmium orange and lay this on top so that the colors merge. Lift out highlights with a dry brush.*

Chinese Lantern
BELL

▶ **2** *When dry, mix cadmium red and cadmium orange. Apply in small strokes to suggest the papery texture, concentrating the color more toward the bottom and on the shaded side.*

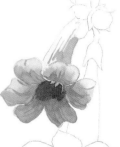

◀ **2** *Starting from the back, paint the petals with a brown madder and cadmium orange mix. Add lines to trumpet and front petals. Darken center with brown madden.*

◀ **3** *Emphasize the ribs with cadmium red and touches of brown madder. For the leaf, lay a wash of green-gold, adding some sap green wet-in-wet. When dry, paint finer details with ultramarine added to the mix, then paint the stem with raw umber and ultramarine.*

▶ **3** *With a dark mixture of brown madder and permanent mauve, paint ridges radiating outward from the trumpet center. Paint the stem and buds with a sap green and olive green mix, adding touches of cadmium orange in places.*

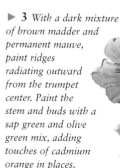

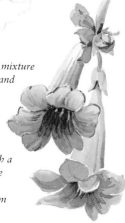

▶ **1** *Paint masking fluid over the beard and stamens. When dry, paint each petal with a loose wash of cadmium orange, leaving patches of white paper. Lift off color on the tips of some petals to suggest the fall of light.*

Nasturtium
Lipped and Bearded

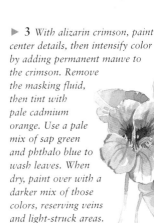

▶ **2** *Shape the rounded petals with deeper cadmium orange and pick out some ridges.*

▶ **3** *With alizarin crimson, paint center details, then intensify color by adding permanent mauve to the crimson. Remove the masking fluid, then tint with pale cadmium orange. Use a pale mix of sap green and phthalo blue to wash leaves. When dry, paint over with a darker mix of those colors, reserving veins and light-struck areas.*

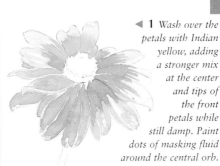

◀ **1** *Wash over the petals with Indian yellow, adding a stronger mix at the center and tips of the front petals while still damp. Paint dots of masking fluid around the central orb.*

▶ **2** *Using a mix of cadmium red and cadmium orange, paint from the center outward. Suggest ridges by feathering the paint out toward the petal tips. Use the strongest color on front petals.*

Rudbeckia
Ray

◀ **3** *When dry, paint darker ridges from the center with a burnt sienna and brown madder mix. Paint the central orb with burnt umber and permanent mauve, lifting out a highlight. Rub off the masking fluid; tint with cadmium yellow. Paint stem using sap green.*

African Marigold

POMPOM

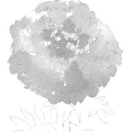

◄ **1** *Paint the whole shape with Indian yellow, deepening the color at the center and bottom with cadmium orange. Leave small patches of white, and avoid laying the color too evenly.*

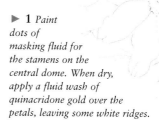

► **1** *Paint dots of masking fluid for the stamens on the central dome. When dry, apply a fluid wash of quinacridone gold over the petals, leaving some white ridges.*

2 *As the paint dries, touch in stronger quinacridone gold to give shape and form to the petals.*

► **2** *Start picking out some of the tiny petals with a mix of brown madder and cadmium orange. Hold the brush vertically, and use the tip to outline the petals. Make them larger at the front and bottom.*

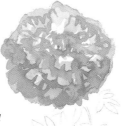

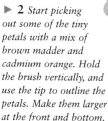

Coreopsis

SIMPLE STAR

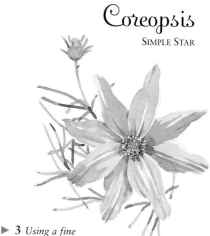

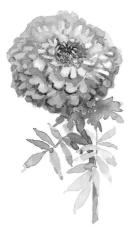

◄ **3** *Continue outlining, this time using strong brown madder, and then drop in small touches of sap green into the center. Paint the leaves in shades of sap green and phthalo blue, adding some strong olive green at the top of the stem.*

► **3** *Using a fine brush and a mix of quinacridone gold and green-gold, paint stronger shadows and ridges. Paint the central dome in sap green with touches of indigo. Remove the masking fluid and tint with lemon yellow, then paint the leaves with crisp strokes of sap green and indigo.*

Globe Buddleia

MULTIHEADED

▶ **1** *Paint masking fluid on the edges of the florets. Suggest the globe shape with a wash graded from Indian yellow on top to cadmium orange at the bottom.*

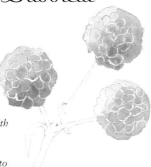

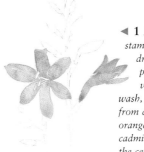

◀ **1** *Mask the stamens. When dry, paint the petals with a variegated wash, changing from cadmium orange at the tips to cadmium yellow at the center.*

Montbretia

SPIKE

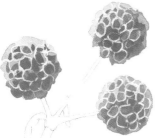

◀ **2** *Lay a brushstroke of cadmium orange in the center of each floret, the size of the strokes decreasing at the top where the form turns away.*

▶ **2** *Build petal forms by shading with a brown madder and cadmium orange mix. Paint small buds with Indian yellow, then overlay with the same mix in the shadows.*

▶ **3** *Dot in the center of each floret with a brown madder and burnt sienna mix. Rub off masking fluid and tint with lemon yellow down to cadmium orange and permanent magenta on the shaded side. Paint the stalks with a mixture of sap green, phthalo blue and green-gold.*

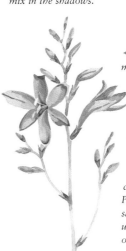

◀ **3** *Mix in brown madder and work into the trumpet center. Use the same color to create edges on the front petals. Rub off masking fluid and paint stamens with cadmium yellow. Paint stalks with sap green; darken under flowers with olive green.*

Red

Lapageria
(Chilean bell-flower)

BELL

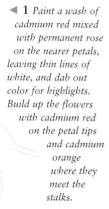

◀ **1** *Paint a wash of cadmium red mixed with permanent rose on the nearer petals, leaving thin lines of white, and dab out color for highlights. Build up the flowers with cadmium red on the petal tips and cadmium orange where they meet the stalks.*

2 *Paint in the back petals with permanent rose and just a touch of cadmium red, and dab lightly on the outer edges. Paint the second flower with a lighter mix.*

▶ **3** *Darken the bell's interior with an alizarin crimson and permanent rose mix, taking the paint around the stamens. Tint with Indian yellow, then add dark shadow edges to the top petals. Paint the leaves and stem with a mixture of sap green, phthalo blue and olive green.*

◀ **1** *Mask out the central clump of stamens, then wash cadmium yellow into the throat of the trumpet and onto the outer edges of the front petals.*

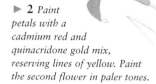

▶ **2** *Paint petals with a cadmium red and quinacridone gold mix, reserving lines of yellow. Paint the second flower in paler tones.*

Hemerocallis
(Day lily)

TRUMPET

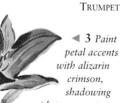

◀ **3** *Paint petal accents with alizarin crimson, shadowing with permanent mauve. Remove masking and paint anthers cadmium yellow and stamens cadmium red. Use a mix of sap green, olive green and phthalo blue for the stalk and leaf.*

Calceolaria (Slipperwort)

LIPPED AND BEARDED

◀ **1** *Apply masking fluid to the small stamens, then paint the pouch of the flower with a fluid wash of cadmium red, allowing it to pool at the edges. While still wet, drop in a little cadmium orange at the top.*

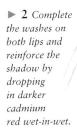

▶ **2** *Complete the washes on both lips and reinforce the shadow by dropping in darker cadmium red wet-in-wet.*

▼ **3** *Paint the markings in alizarin crimson, adding permanent mauve for shading. Use the same dark mixture for the flower throat. Rub off the masking and tint stamens with lemon yellow. Paint the leaflets in sap green and olive green, and the stalk in two tones of olive green.*

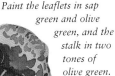

▶ **1** *Dampen each petal in turn with a brush dipped in clean water and drop in a bright red/cadmium red mixture. The paint will flow outwards, stopping when it meets dry paper.*

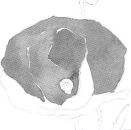

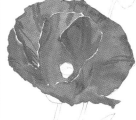

◀ **2** *While still damp, take up cadmium red on the tip of a fine brush and lightly draw lines following the curvature of the petals.*

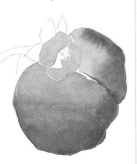

Field Poppy

CUP AND BOWL

▶ **3** *Darken parts of the petals with a strong bright red/cadmium red mix. Add alizarin crimson to petal edges. Paint dome in pale green-gold; paint the stamens and dome details with indigo. Use a sap green/cobalt blue mix for the leaf, stem and bud, making the bud paler. Touch in some hairs.*

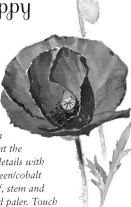

Zinnia

POMPOM

▶ **1** *Lay a touch of lemon yellow in the center, followed by a wash of permanent rose and bright red on the rest of the flower.*

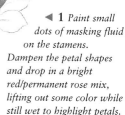

◀ **1** *Paint small dots of masking fluid on the stamens. Dampen the petal shapes and drop in a bright red/permanent rose mix, lifting out some color while still wet to highlight petals.*

Rosa Moyesii

SIMPLE STAR

◀ **2** *Mix bright red with alizarin crimson and start to outline some of the petals, concentrating the most color on the shaded side so less of the first wash shows. Dab out color at the top of the head where it catches the light.*

▶ **2** *Build up the forms of the petals with a stronger mix of the same colors.*

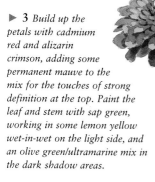

▶ **3** *Build up the petals with cadmium red and alizarin crimson, adding some permanent mauve to the mix for the touches of strong definition at the top. Paint the leaf and stem with sap green, working in some lemon yellow wet-in-wet on the light side, and an olive green/ultramarine mix in the dark shadow areas.*

◀ **3** *Touch in alizarin crimson and permanent mauve behind the stamens and on some petal edges. Paint the center with sap green and lemon yellow. Remove the masking and tint with cadmium yellow. Paint branch with raw umber. Color leaves with a sap green and cobalt blue.*

► **1** *Taking the brush outward from the centers, paint each floret separately with a mix of cadmium red and alizarin crimson, changing to crimson/ ultramarine on the lower petals.*

2 *Starting at the top, paint small dark shapes behind the petals with alizarin crimson, adding some ultramarine for the lower florets.*

Hollyhock
SPIKE

◄ **1** *Touch in the flower centers with cadmium yellow and leave to dry. Wash over each flower with a mid-toned cadmium red, lifting out highlights on the lower petals.*

2 *Add deeper cadmium red in the shadow areas, softening the edges with a damp brush. While still wet, drop in a little alizarin crimson around the center of the left-hand flower.*

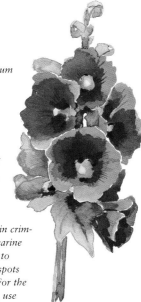

Sweet William
MULTIHEADED

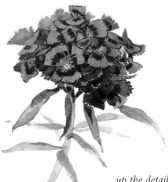

◄ **3** *Build up the detail by painting the markings with strong crimson, then add ultramarine and darken the lower petals. Use the same strong mixture to crisp up the petal edges, using short, stabbing brushstrokes. Paint the leaves with a mixture of sap green, green/gold and ultramarine, making them darker beneath the head.*

► **3** *Build up the flowers with a alizarin crimson, then add ultramarine and use a fine brush to touch in the central spots and vein markings. For the leaf, stem, and buds, use mixtures of sap green, olive green and ultramarine, making the color darkest beneath and behind the flowers.*

Parrots on Blue

Adelene Fletcher
(22½" x 19")

Parrot tulips, with their showy crinkled petals and two-toned coloring, have intrinsic drama, which has been captured in this painting by the use of two strong primary colors, red and blue. The composition is unified by the repetition of the blue—ultramarine and phthalo blue—throughout the picture in differing forms, so that it forms a framework for the vibrant reds. In the center of the picture, complementary contrast is used, with the green foliage drawing the eye to the main flower. Flower colors range from pale cadmium orange and scarlet through to deeper magenta and crimson.

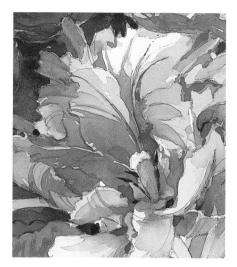

◀ *The center of this flower holds our attention, forming a quiet contrast to the flamboyant curling petals around it. Areas of dark red and purple add emphasis to reinforce the focal point.*

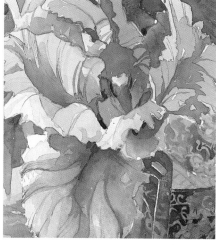

▶ *Here both shading and contour lines have been used to describe the form of the petals. The spidery vein markings that give this flower much of its character have been painted with a fine rigger brush.*

▶ *Throughout the painting the feeling of excitement has been maintained through strong combinations of brilliant colors. This flower has been built up with a variety of reds from permanent rose and cadmium red through to crimson and magenta. Notice how skillfully the turned-over edges of the petals have been described by taking darker colors around them.*

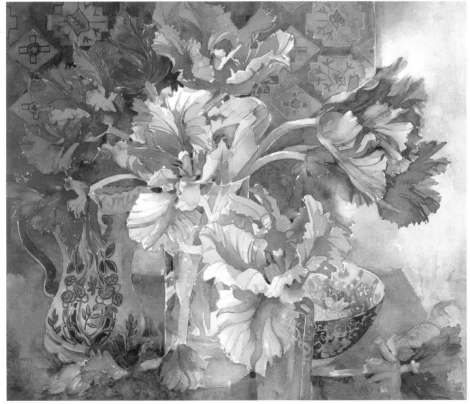

Pink

Pulsatilla

Vulgaris Rubia ("Pasque Flower")

BELL

▶ **1** *Mix cadmium red with a little lemon yellow and lay a variegated wash, leaving linear white highlights. While damp, add cadmium yellow to the pointed petals on the right.*

◀ **1** *Paint a strong wash of permanent rose over the top petals of the main flower, then use a dry brush to lift out some of the color at the top.*

Alstroemeria

TRUMPET

▶ **2** *Touch in quinacridone gold for the stamen boss. Shadow the lower petals using a mix of permanent magenta and permanent rose.*

◀ **2** *Paint the trumpet and ridges on the yellow petals with an alizarin crimson/ quinacridone gold mix, and add darker touches on the tips of the pink petals.*

▶ **3** *With a stronger mix of the same colors, paint more petal ridges, then add permanent mauve and paint the trumpet details, the stamens and the dark markings. Use quinacridone gold for the anthers, and paint the bud loosely with a combination of the previous colors. Fill in the leaf and stalks with sap green, darkened with olive green and phthalo blue.*

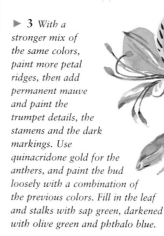

▼ **3** *Using the same mixture, add shadow detail to the top petals. Deepen the mix with permanent mauve, and paint inside the bell. For the background flower, use paler mixtures of the same colors. Paint the foliage using first cobalt green, then olive green and phthalo blue.*

Everlasting Pea

LIPPED AND BEARDED

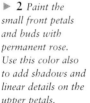

◀ **1** *Wash over the fan-shaped upper petals with a mix of permanent rose and permanent mauve, then dab with a tissue to highlight.*

▶ **1** *Apply masking fluid on the stamens. Paint each petal with a mix of permanent rose and bright red, lifting out where they catch the light.*

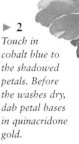

▶ **2** *Paint the small front petals and buds with permanent rose. Use this color also to add shadows and linear details on the upper petals.*

▶ **2** *Touch in cobalt blue to the shadowed petals. Before the washes dry, dab petal bases in quinacridone gold.*

Camelia

CUP AND BOWL

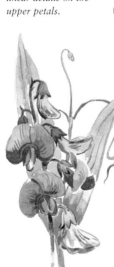

◀ **3** *Use a stronger version of the original mix to build up the flowers with darker accents. Paint the foliage starting with a sap green/ultramarine mix, darkening with olive green.*

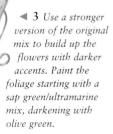

▶ **3** *Create shadow with a permanent rose/ permanent magenta mix. Soften the edges with the side of a damp brush. Remove the masking and tint with raw sienna and cadmium yellow. Add magenta for the anthers. For the dark leaves, use mixes of cobalt blue, sap green and olive green worked wet-in-wet.*

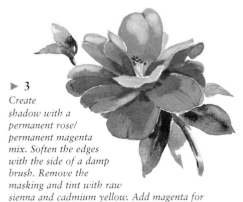

Dahlia

POMPOM

▶ **1** *Begin painting the flower center, using a mix of permanent rose and cadmium yellow, then change to permanent rose alone, gradually adding magenta. Leave lines of white at the edges of the petals. Dab out some color from the center.*

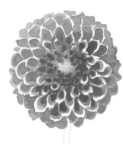

◀ **2** *Paint into the centers of the florets on the shaded side with a strong permanent rose/magenta mix, but leave those at the outside edge as they are.*

▶ **3** *Using the same mix but darkened slightly with permanent mauve, continue to emphasize the florets, building up the center with smaller strokes. Paint the stem with sap green, dropping in olive green for the dark shadow at the top.*

▶ **1** *Paint the center with cadmium yellow and leave to dry. Wet each petal in turn, leaving lines of dry paper. Quickly flood in a wash of permanent rose. Lift off color in the center up to the yellow.*

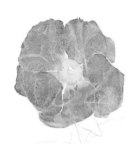

◀ **2** *With the paint still wet, lay down a piece of cling wrap, press it down gently and leave it to dry completely before removing it.*

Cistus

SIMPLE STAR

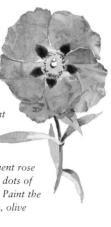

▶ **3** *Emphasize the light lines left by the film by painting on either side of them. Add a thin glaze of cobalt blue in the shadowed areas. Paint the dark markings with cadmium red. When almost dry, dab in a permanent magenta/permanent rose mix. For the stamens, paint dots of raw sienna/permanent rose. Paint the leaves in mixes of sap green, olive green and lemon yellow.*

*◀ **1** Mask out the stamens, then paint the petals with a mid-toned wash of permanent rose and lemon yellow.*

*▶ **2** Paint in the shadows on the light side with stronger permanent rose, and those on the dark side with permanent magenta.*

Lupin
SPIKE

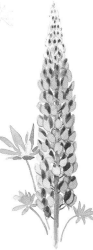

*▶ **1** Starting at the top of the spike, wash in green-gold and lift out on the light side. Change to permanent rose, allowing this to mix with the green-gold.*

*◀ **2** Continue to strengthen the color down the spike, adding cobalt blue to the permanent rose on the shadowed side. Start building up the floret shapes.*

Red Campion
MULTIHEADED

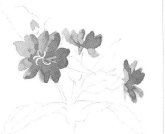

*◀ **3** Emphasize the flower centers with dabs of permanent mauve, then rub off the masking and tint with raw sienna. For the calyxes and stems, use a mix of sap green and alizarin crimson, finishing with a fine brush for the hairs. For the leaves, lay washes of sap green and cobalt blue, leave to dry and add detail with an olive green/sap green mix.*

*▶ **3** Add darker details with permanent mauve. At the top of the spike, outline the small buds with sap green. Paint the palmate leaves and the stem with a mix of sap green and olive green, adding ultramarine for the dark shadows.*

BOWL OF BEAUTY

Janet Whittle
(13" x 18")

THE COMPOSITION IS carefully structured, with the group of flowers arranged in a roughly triangular shape, framed by the leaves. These have been allowed to go out of the frame at the edges, which helps to focus attention on the flowers as well as giving a sense of life and movement. Strong tone and color contrasts convey the effect of light, not only on the blooms but also in the background, where pale yellow-greens and cool, pale blues change to deep indigo to contrast with the main flower.

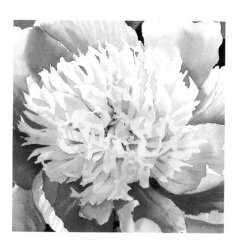

◄ *The central tightly packed stamens collect to form a compact shape. Individual stamens have been picked out by means of negative painting to explain the intricate structure, with the strongest color and tone contrasts used in the foreground.*

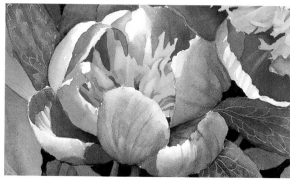

► *The petals of the bowl-shaped flower spiral out from the center and curve inwards, throwing strong shadows that describe the forms. Notice how the artist has left some edges crisp and clear but softened others to give the impression of the gentle, rounded curves.*

◀ The leaves have been painted with the minimum of overall tonal contrast to allow the focus to stay with the flowers, but depth has been created by varying the treatment. The nearer leaves, just behind the flower head, have sufficient detail to stand out from those behind.

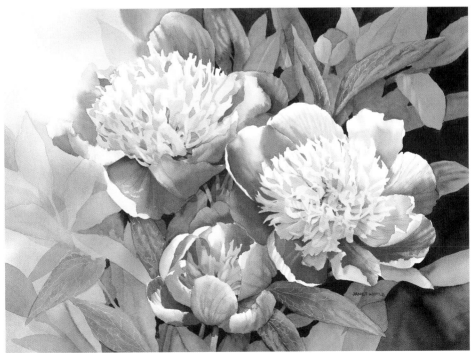

Purple
Campanula
(Canterbury bell)

BELL

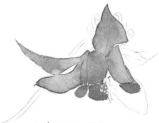

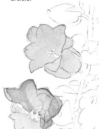

◀ **1** *Mask off the stamens. When dry, paint the bells with a mix of permanent mauve and permanent magenta.*

▲ **1** *Mask off the stamens. Lay a light variegated wash over the petals, using permanent mauve and magenta, adding ultramarine for the shadowed areas.*

▶ **2** *While wet, dab ultramarine into the centers. Paint the stalk and leaves with a green-gold/cobalt blue mix. For buds, lay over a light violet.*

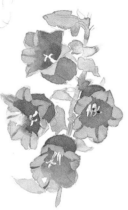

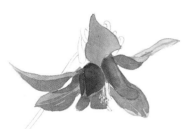

▲ **2** *Paint the trumpet in stronger permanent mauve, then use a lighter mix to establish ridges and shadows on the petals that form the frill.*

Columbine

TRUMPET

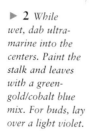

◀ **3** *Paint into the bells with strong dioxazine violet, leaving sharp edges to define the top petals. Use the same color to add darker ribs to the bell bowl and details on the bud. Build up dark shadows on the stalk and leaves with a sap green/olive green mix.*

▶ **3** *With dioxazine violet, paint linear details on the trumpet to give it form, lifting out a vertical highlight by wetting with a fine brush and then blotting out. Paint the back spurs in shades of ultramarine, and add details on the frill petals with mid-toned violet. Rub off the masking and tint with green-gold and quinacridone gold.*

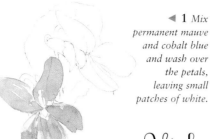

◄ **1** Mix permanent mauve and cobalt blue and wash over the petals, leaving small patches of white.

Violet

LIPPED AND BEARDED

► **1** Paint each petal separately, starting with the two at the front. Wet the paper and lay on a mix of permanent mauve, magenta and a touch of indigo, tipping the paper so that the paint pools are at the bottom. While the wash is still damp, suggest some ridges following the forms of the petal.

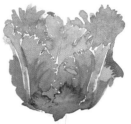

► **2** Build up the forms with a permanent mauve and ultramarine mix, adding wavy petal lines. Paint the opening bud with a pale wash of those colors.

◄ **2** For the back petals, add ultramarine to the mix, leaving a little white paper showing to mark the division.

Black Parrot Tulip

CUP AND BOWL

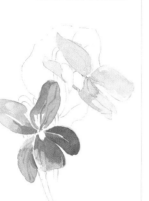

◄ **3** Complete the main flower with dark dioxazine violet. Paint the center with quinacridone gold. Add detail on the other flower using mid-toned violet, with some permanent magenta for the back spur. For the leaf, use a wash of green-gold and cobalt blue. The stems and spur leaves are sap green, darkened with olive green.

► **3** Build up the near petals with a stronger mix of the first colors, using more mauve. Paint dark shapes between the petals. Finish the back petals with tones of dioxazine violet, darkest where the front and back petals meet. Emphasize the nearest dark details with permanent mauve and indigo. The stem is sap green, with a touch of magenta at the top.

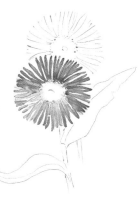

► **1** *Mask off the stamens surrounding the centers, then paint the front flower with crisp strokes of a fine brush, using a mix of permanent magenta and ultramarine.*

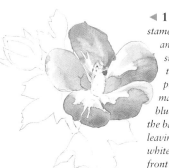

◄ **1** *Mask the stamens and top anthers with small dots, then wash a permanent mauve/cobalt blue mix onto the back petals, leaving areas of white. For the front petals, add permanent rose to the mix.*

Erigeron (Fleabane)

RAY

Hibiscus

SIMPLE STAR

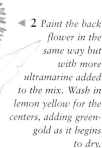

◄ **2** *Paint the back flower in the same way but with more ultramarine added to the mix. Wash in lemon yellow for the centers, adding green-gold as it begins to dry.*

► **2** *Strengthen the first washes and build up the shadows, then paint the bud with a mix of green-gold and cobalt blue.*

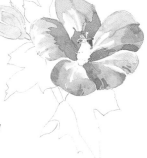

► **3** *Using a strong magenta/ultramarine mix, pick out the top and bottom petals on the foreground flower. Build the back flower in a paler tone. Rub off the masking; tint with cadmium yellow. Use a mixture of sap green and olive green for the leaves and stem.*

◄ **3** *Paint the blotches at the petals' bases with strong magenta. Add dark indigo details when semi-dry. Paint back leaves with mixes of green-gold and cobalt blue, adding mauve where they meet the flowers. Finish bud with darker sap green. Remove the masking. Tint bud with pale raw sienna.*

Lilac

MULTIHEADED

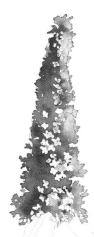

◀ **1** *Paint some of the nearer open florets with cobalt violet, then add permanent mauve for the top buds and the shaded florets at the bottom.*

◀ **1** *As the small florets are numerous, mask out just some of the central ones, then start on the light side with a mid-toned permanent mauve/permanent magenta mix, stippling the edge to suggest the tiny petals. Work toward the shaded edge, increasing the strength of color.*

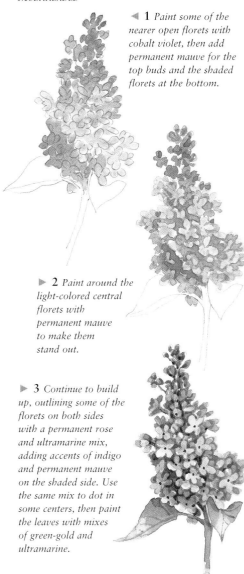

▶ **2** *Paint around the light-colored central florets with permanent mauve to make them stand out.*

Buddleia

SPIKE

2 *Build up the cone shape by painting darker details on the shaded side. Add more mauve to the mix using the tip of a well-loaded brush. When dry, rub off the masking.*

▶ **3** *Continue to build up, outlining some of the florets on both sides with a permanent rose and ultramarine mix, adding accents of indigo and permanent mauve on the shaded side. Use the same mix to dot in some centers, then paint the leaves with mixes of green-gold and ultramarine.*

▶ **3** *Tint the white shapes with cobalt violet/permanent rose, and dot in the centers with brown madder/permanent rose. Paint the leaves with a mixture of green-gold and phthalo blue, with a dark ultramarine shadow beneath the flower.*

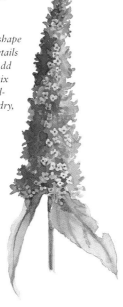

► **1** *Mask off some of the nearest spidery star shapes, then use a fine brush and a fairly dry permanent mauve/cobalt violet mix to paint a network of fine lines radiating out from the floret centers.*

Allium
(Ornamental onion)
POMPOM

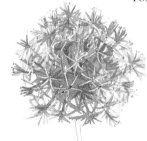

◄ **2** *Using a darker mix of the same colors, plus small touches of burnt sienna, build up more star shapes, concentrating color in the center of the sphere shape.*

► **3** *Weave olive green into the center. Add strong permanent mauve to build depth. Remove masking and paint the star centers in cadmium yellow, emphasizing with dioxazine violet. Paint the stem in sap green, with olive green shadow.*

Hyacinth
MULTIHEADED

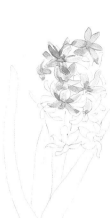

◄ **1** *Paint the florets with a dryish mixture of permanent mauve and ultramarine. When dry, glaze a thin wash of permanent rose on the lighter side.*

► **2** *Paint in some shapes behind the front florets with a mid-toned mauve, then add ultramarine and darken those on the shaded side. Use a fine brush to outline the more prominent florets in mauve.*

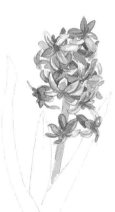

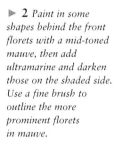

◄ **3** *Using dioxazine violet, dot in the centers and build up the small areas of dark behind the florets and on the shaded side. Paint the strap leaves and stalk with a mix of sap green, cobalt blue and olive green, using a higher proportion of blue for the back leaf.*

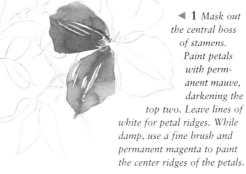

◀ **1** *Mask out the central boss of stamens. Paint petals with perm-anent mauve, darkening the top two. Leave lines of white for petal ridges. While damp, use a fine brush and permanent magenta to paint the center ridges of the petals.*

▶ **1** *Dot masking fluid in the stamens around the central boss. Paint the left-hand flower with strong strokes radiating from the center, using a mix of permanent mauve and cobalt violet.*

▶ **2** *Darken the ridges on the top petals with touches of dioxazine violet. When dry, rub off the masking.*

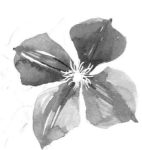

Michaelmas Daisy
RAY

▼ **2** *Paint the right-hand flower with violet, and those in the background with a paler mix of violet and ultramarine. Build up darker tones on the front flowers with a wash. Paint the centers with cadmium yellow.*

Clematis Jackmanii
SIMPLE STAR

◀ **3** *Paint the stamens with lemon yellow, adding detail with permanent mauve, then paint the leaves and stem with mixes of green-gold and phthalo blue, darkening with olive green. Glaze thin magenta over the stem and bud.*

▶ **3** *Add more shadows using permanent mauve, with dioxazine violet at the centers. Lift masking. Tint with cadmium yellow. Glaze a shadow on the centers with thin mauve. Paint leaves and stalk sap green and olive green.*

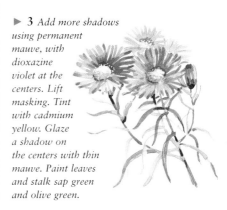

Blue

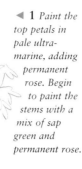

◀ **1** *Paint the top petals in pale ultramarine, adding permanent rose. Begin to paint the stems with a mix of sap green and permanent rose.*

▶ **1** *Paint the flower shapes with a mix of ultramarine and permanent mauve, dropping in more ultramarine on the shaded side as the paint dries.*

Scilla

BELL

▶ **2** *For the undersides of the flowers, use stronger mixes of the same colors, and add some background shapes between the flowers with cobalt blue.*

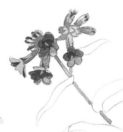

◀ **2** *When dry, lift out the styles with a fine, damp brush. Tint with Naples yellow. Add shadows to the flowers with dioxazine violet, using two tones for the buds. Use two tones of sap green for calyxes.*

Pulmonaria
(Lungwort)

TRUMPET

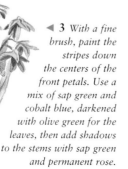

◀ **3** *With a fine brush, paint the stripes down the centers of the front petals. Use a mix of sap green and cobalt blue, darkened with olive green for the leaves, then add shadows to the stems with sap green and permanent rose.*

▶ **3** *Add indigo to the flower centers for depth. Add dark details to the buds and calyxes. Paint each spotted leaf in turn, starting with mid-toned washes of sap green and olive green; quickly lift out color with a tissue wrapped around the end of a brush. When dry, add darker details with olive green.*

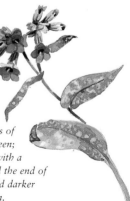

Wisteria
LIPPED AND BEARDED

▶ **1** *Paint a light wash of dioxazine violet on the upper lips of the open flowers, leaving white highlights. While wet, drop in quinacridone gold at the base of the lips.*

◀ **1** *Mask out the three-pronged styles, then flood the back petals with cobalt blue, tipping the paper so that it pools at the center. Paint the nearer petals in a lighter tone, leaving a tiny edge of white.*

2 *Add dioxazine violet to the blue and paint into the dark centers, pulling the paint into the petal ridges.*

◀ **2** *Paint the buds and lower part of the open flowers with permanent mauve, dropping in cobalt blue while wet, and softening the edges where the lips meet with a damp brush.*

Campanula Carpatica
LIPPED AND BEARDED

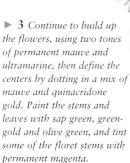

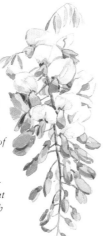

▶ **3** *Continue to build up the flowers, using two tones of permanent mauve and ultramarine, then define the centers by dotting in a mix of mauve and quinacridone gold. Paint the stems and leaves with sap green, green-gold and olive green, and tint some of the floret stems with permanent magenta.*

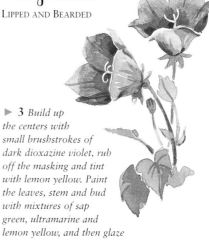

▶ **3** *Build up the centers with small brushstrokes of dark dioxazine violet, rub off the masking and tint with lemon yellow. Paint the leaves, stem and bud with mixtures of sap green, ultramarine and lemon yellow, and then glaze over the bud with violet.*

Sea Holly

RAY

▶ **1** Mask the tiny flowers in the center. Starting at the top, paint the spiny bracts in pale cobalt blue. Toward the lower bracts, add dioxazine violet.

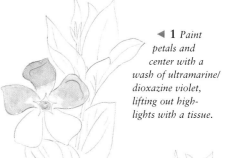

◀ **1** Paint petals and center with a wash of ultramarine/dioxazine violet, lifting out highlights with a tissue.

◀ **2** Add an ultramarine/phthalo green mix to the bract bases. Glaze lower bracts with olive green. Paint flower top cobalt green, and bottom permanent mauve.

▶ **2** Build up the petal shadows with a stronger mix of the same colors, softening the edges with a just-damp brush.

Periwinkle

SIMPLE STAR

▶ **3** Pick out some of the spines with a mix of olive green and mauve. Use the same mix for the stem. Paint the flower head with pale indigo on the shaded side, and dab stronger indigo onto the bracts between the flower. Rub off the masking and tint the central row of flowers with ultramarine.

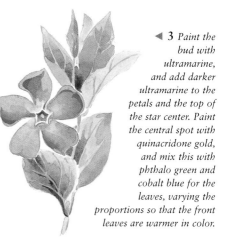

◀ **3** Paint the bud with ultramarine, and add darker ultramarine to the petals and the top of the star center. Paint the central spot with quinacridone gold, and mix this with phthalo green and cobalt blue for the leaves, varying the proportions so that the front leaves are warmer in color.

▶ **1** *Mask out some of the stamens. Paint the flowers with diluted ultramarine. While wet, drop in pale permanent rose. As the paint dries, add more ultramarine to throats.*

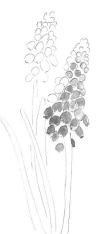

Agapanthus
MULTIHEADED

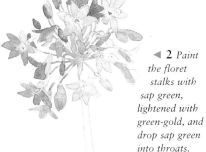

◀ **2** *Paint the floret stalks with sap green, lightened with green-gold, and drop sap green into throats.*

▶ **3** *Build up detail with a mix of ultramarine and dioxazine violet. Paint stripes down the open florets' petals. Rub off the masking. Tint the anthers with indigo. Strengthen stems and stalk with sap green.*

◀ **1** *Using a fine brush, paint the tiny bells with cobalt blue, using a deeper mix on the shaded sides, and leaving small highlights on the buds. While wet, dot in permanent rose on the top edge of the flowers and let it blend.*

▶ **2** *Paint the stalk with green-gold, darkening it with cobalt blue and olive green at the top. Paint the second spike in two tones of cobalt blue.*

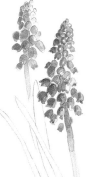

Muscari
(Grape Hyacinth)

SPIKE

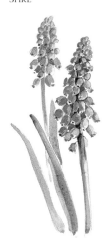

◀ **3** *Paint the small negative shapes of background bells with ultramarine, dotting some of the centers with indigo. Strengthen the stalk's center with a phthalo green/olive green mix. Paint the back leaf and stalk with sap green, washing green-gold over the nearer ones. Shade with phthalo/olive green mix.*

SUMMER BREEZE

Richard French
(30" x 40")

THIS PAINTING MAKES use of ingenious and carefully planned effects. The view focuses first on the pattern created by the hollyhocks, wall and window, but the eye is then led in through the window to the distant view with its window box that echoes the one in front. This acts as a reminder to come back to the front of the picture and observe how the free shapes of the flowers contrast with the geometry of wall and window.

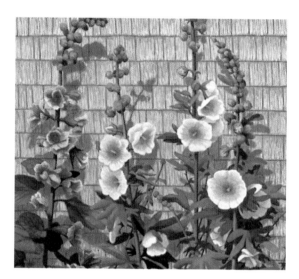

◀ *The hollyhocks have been painted in meticulous botanical detail, in keeping with the overall treatment, and their spikes varied from uprights to curves to give a feeling of life and movement that contrasts with the static man-made structures.*

▶ *The eye is drawn to the geraniums because of the way they are framed by the strong dark and light of the window, but the artist has unified the composition by setting up color links. The hollyhocks on the left are similar in color, providing warm notes in an otherwise cool color scheme.*

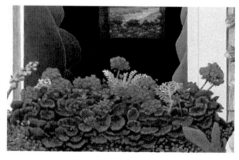

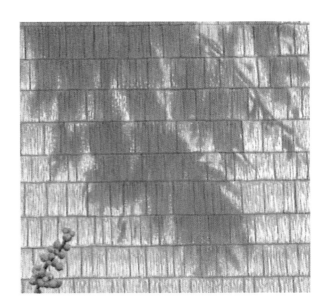

▶ *The shadow pattern is important to the composition, as it helps to balance the dominant shape of the window as well as echoing the free shapes of the flowers beneath.*

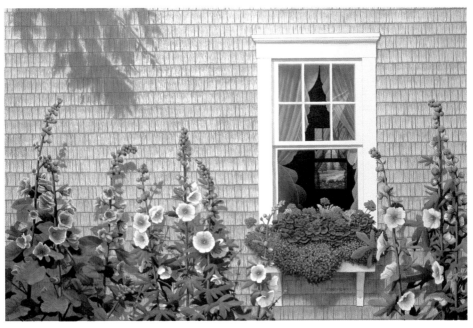

White, Cream and Green

◀ **1** *Paint green-gold onto the light-catching bells and leaves, blending in cobalt green wet-in-wet on the shaded sides, and then touching in brown madder at the bottom of the petals. For the background leaves, add cobalt blue to the mix.*

▶ **1** *Lay a light wash of green-gold all over the flowers and stems, then add more color in the shaded areas. When dry, wash phthalo blue over the yellow on the underside of the petals of the top flower.*

Hellebore
(Stinking Hellebore)

BELL

▶ **2** *Mix sap green and phthalo green and paint the insides of the bells, then add cobalt blue and start to paint the dark areas on the leaves.*

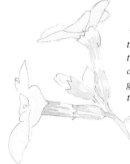

◀ **2** *Paint in the ridges down the trumpet and calyx with sap green, continuing the color down the stem.*

Nicotiana
(Tobacco Plant)

TRUMPET

▲ **3** *Intensify the green inside the bells using sap green mixed with indigo. Darken the leaves behind the bell with the same mix.*

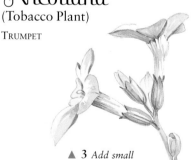

▲ **3** *Add small details on all parts of the flowers with an indigo and green-gold mixture.*

▶ **1** *Mask out all stamens. Paint a wash of phthalo blue around the cluster; let dry. Tint buds with a sap green/Naples yellow mix. Paint tubes with diluted Naples yellow and lemon yellow, leaving highlights.*

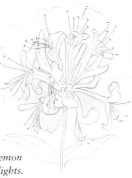

◀ **2** *Drop cadmium yellow into the flowers' throats. Darken the turned petals with Naples yellow and sap green. Paint the central small buds and leaves with darker sap green.*

Lonicera
(Honeysuckle)

LIPPED AND BEARDED

▶ **3** *Build up the flowers with a raw umber and Naples yellow mix, then define the central buds and leaves with sap green and olive green.*
Rub off the masking. Paint the anthers with quinacridone gold. Paint the large leaves and stem with cobalt green/sap green, darkening with olive green.

▼ **1** *Mask out the central stamens; lay a pale olive green background wash. Paint petals with a wash of Naples yellow, leaving highlights. Add lemon yellow to the flower's center; feather outward.*

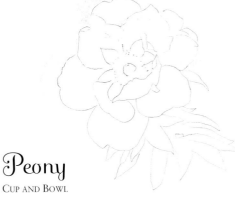

Peony
CUP AND BOWL

2 *For the shadows on the petals, start with a mix of cobalt blue and cobalt green, then darken it by adding quinacridone gold and more blue.*

▼ **3** *Paint the central star with a dioxazine violet/permanent magenta mix, varying the tones. Remove the masking; tint with cadmium yellow and burnt sienna. Paint leaves mainly wet-in-wet, using mixtures of cobalt green, cobalt blue and green-gold; add indigo for shadow.*

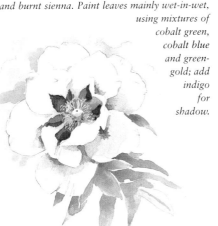

Shasta Daisy

RAY

▶ **1** *Paint a light wash of ultramarine around the light-catching top petals. Work the centers of the flowers with short brushstrokes of cadmium yellow, fading the color outward by progressively watering it.*

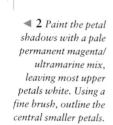

◀ **2** *Paint the petal shadows with a pale permanent magenta/ ultramarine mix, leaving most upper petals white. Using a fine brush, outline the central smaller petals.*

▶ **3** *Strengthen the shadowed petals with ultramarine, then partially outline them with a strong ultramarine/dioxazine violet mix. Drop cadmium orange into the centers; strengthen with dioxazine violet. Paint the stem and leaves with phthalo green and olive green.*

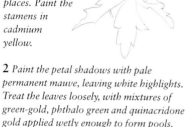

▶ **1** *Outline the petals with a variegated wash of green-gold and cobalt blue, overlaying the leaves in places. Paint the stamens in cadmium yellow.*

2 *Paint the petal shadows with pale permanent mauve, leaving white highlights. Treat the leaves loosely, with mixtures of green-gold, phthalo green and quinacridone gold applied wetly enough to form pools. Make the color bluer as the leaves recede.*

Wood Anemone

SIMPLE STAR

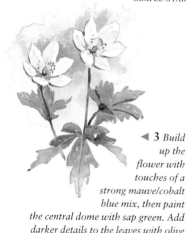

◀ **3** *Build up the flower with touches of a strong mauve/cobalt blue mix, then paint the central dome with sap green. Add darker details to the leaves with olive green and phthalo green; wash over the stem with mauve to give a pinkish tinge.*

Prunus Blossom
"Ukon"

MULTIHEADED

▶ **1** *Wash around the upper petals with pale ultramarine. Paint the petal shadows with a raw sienna/ cobalt blue mix, leaving lots of white. Darken as you reach the lower petals.*

◀ **1** *Lightly touch the lower bells with Naples yellow before placing a background wash around the shapes. Paint wet-in-wet, starting with lemon yellow and gradually adding phthalo green and cobalt blue. Use the same colors to paint the throats and shadows of the bells.*

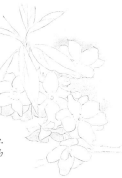

◀ **2** *Deepen the shadows, using the same colors, but with more blue. Lay a wash of quinacridone gold/green-gold on the foliage, varying the tones. Tint the buds and small leaves behind the flowers with sap green.*

▶ **2** *Paint the twig with a burnt sienna/olive green mix, varying the tone by dabbing with a tissue in places. Touch in the spiky leaflets with sap green.*

Heather

SPIKE

▶ **3** *Build up the shadows in the deepest crevices with touches of indigo. Add some stamens in indigo and brown madder. To give the leaves form, paint in veins with a strong burnt umber and olive green mix.*

◀ **3** *Emphasize the twig and floret centers with specks of dark indigo. Outline some florets using a mid-toned indigo.*

QUEEN ANNE'S LACE AT THE BRIDGE

Mary Lou Ferbert
(48" x 48")

THE THEME OF this painting is contrast—unusual juxtapositions and contrasting textures. A tension is created between the soft, delicate, living flowers and the rusting, crumbling metalwork, giving an almost Surrealist effect. The painting has been built up slowly, with each part treated with meticulous care, and the mainly neutral coloring exploits the whole tonal range from white to near-black.

▼ *Dark background color has been taken around the flower heads, which have then been carefully modeled with various shades of pale gray-green and yellow. In places, edges have been softened with a damp brush.*

◀ *The stems are brought forward to the front of the picture plane by letting them go out of the frame at the bottom. A realistic three-dimensional effect has been created by careful shading, from pale yellow-green where the stems catch the light to deep blue-green for those in shadow.*

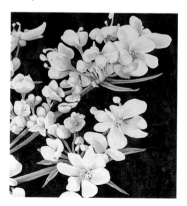

▶ *A little more gray has been used for the more distant flowers, but recession has been suggested mainly through perspective, with the larger floret in the foreground explaining the spatial relationship.*

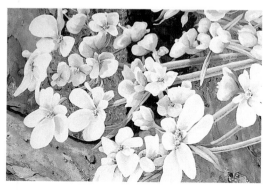

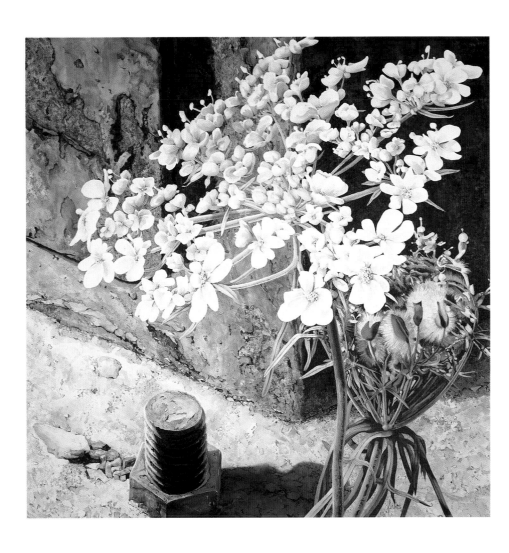

Berries

▶ **1** *Starting with the nearest berries, paint using Indian yellow; leave a small highlight on each one. Paint those farther away with cadmium orange; do not highlight.*

Pyracantha
(Fire Thorn)

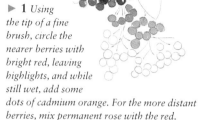

▶ **1** *Using the tip of a fine brush, circle the nearer berries with bright red, leaving highlights, and while still wet, add some dots of cadmium orange. For the more distant berries, mix permanent rose with the red.*

◀ **2** *Using a cadmium orange/burnt sienna mix, build up the forms of the nearer berries. Soften the edges immediately with a damp brush. Mix in brown madder for the back berries. Paint leaves using sap green, lemon yellow and phthalo green mixes. Paint branches using burnt umber and phthalo green.*

2 *Paint the leaves with a mixture of sap green, green-gold and phthalo green, adding cobalt blue for the background leaf. Add the twigs using raw umber mixed with alizarin crimson.*

Cotoneaster

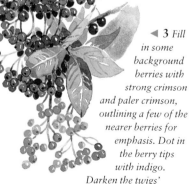

▶ **3** *Strengthen the tones on both the leaves and berries, using stronger mixes of the previous colors, but with indigo added for the leaves. Dot in the tips of the berries with burnt umber. Using a permanent mauve/burnt umber mix, paint the thin twigs and add darker touches to the branch.*

◀ **3** *Fill in some background berries with strong crimson and paler crimson, outlining a few of the nearer berries for emphasis. Dot in the berry tips with indigo. Darken the twigs' shadows with burnt umber. Add detail to the leaves using sap and olive green. Paint simple shapes for the back leaves, using cobalt blue and phthalo green.*

▶ **1** *Mask out some of the tiny twiglets in the centers of the bunches. Paint the nearest berries with a mix of cobalt blue and phthalo green, dropping in a little green-gold wet-in-wet. For the other berries, use mixes of cobalt blue and dioxazine violet, leaving small white lines to separate them.*

2 *Build up the forms with dioxazine violet on the nearer berries, and use a violet/permanent mauve mix on the background ones, softening the edges while still damp. Paint in the stem with raw umber.*

Mahonia

▶ **3** *Continue to build up, using stronger mixes of the same colors. Use indigo for the deepest shadows and the berry tips. Paint the leaves loosely, with mixes of cobalt green, phthalo green and cobalt blue, then darken the main branch with burnt umber. Remove the masking and tint with raw umber.*

◀ **1** *Outline the berries on the light side with a variegated wash of cobalt blue and phthalo green. Paint the shaded sides of the berries with Naples yellow, adding burnt umber towards the shaded side, leaving less white.*

Symphoricarpos Rivularis
(Snowberry)

▶ **2** *With weak cobalt blue, paint shadows on each berry, darkening the blue with burnt sienna on the shaded side.*

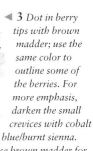

◀ **3** *Dot in berry tips with brown madder; use the same color to outline some of the berries. For more emphasis, darken the small crevices with cobalt blue/burnt sienna. Use brown madder for the twigs, and olive green and phthalo green mixes for the leaves.*

Leaves

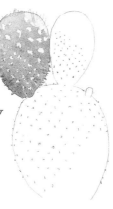

► **1** *Mask out some of the prickles. Lay a wash of sap green on the top pad, adding lemon yellow at the top, and olive green at the lower edge, then tipping the paper to distribute the color. While still wet, tease out the paint at the edges with a fine brush or pen, and then lift out more light spines with a tissue wrapped around a pencil tip.*

Cactus Opuntia
(Prickly Pear)

◄ **2** *Paint the other pads using the same method, but for the larger, parent pad, change to a mix of indigo and sap green, with cobalt blue dropped in while wet.*

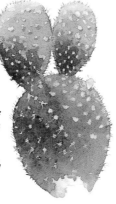

► **3** *Before the paint dries fully, carefully dot in more dark color, using strong olive green on the top pads and an indigo/olive green mix on the large one. When dry, rub off the masking and tint with pale sap green.*

Fern

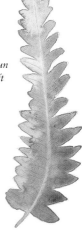

◄ **1** *Start at the top of the leaf with sap green, keeping the paint very fluid. As you work down the leaf, add olive green first, and then add phthalo green towards the bottom.*

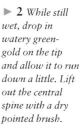

► **2** *While still wet, drop in watery green-gold on the tip and allow it to run down a little. Lift out the central spine with a dry pointed brush.*

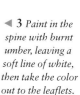

◄ **3** *Paint in the spine with burnt umber, leaving a soft line of white, then take the color out to the leaflets.*

▼ **1** *Paint a wash of Naples yellow over the leaf, leaving a white highlight where the leaf turns over. Darken the color on the shaded side with the addition of green-gold.*

◀ **1** *Lay a variegated wash of lemon yellow, raw sienna and phthalo blue on both leaves, leaving some white highlights. Leave to dry.*

Hosta

▲ **2** *When dry, take a light glaze of cobalt blue over the shadow areas: the undersides, the leaf ribs and the curve where the leaf turns down into the spine.*

▶ **2** *Paint a second wash of phthalo blue, painting around some of the ribs and adding some veins with the same color.*

Golden Hop

◀ **3** *Paint between the ribs with a mix of cobalt green and phthalo blue, then strengthen the colors in the main shadow area by adding indigo.*

▶ **3** *For the darker shadow areas, use a stronger mix of the same blue to add further emphasis to the leaf ribs.*

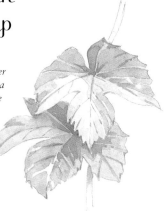

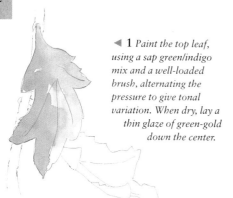

◀ **1** *Paint the top leaf, using a sap green/indigo mix and a well-loaded brush, alternating the pressure to give tonal variation. When dry, lay a thin glaze of green-gold down the center.*

◀ **1** *Paint a loose wash of cobalt green around the veins, then darken a little on the shaded side with sap green. When dry, glaze on some lemon yellow, leaving white highlights.*

Chrysanthemum

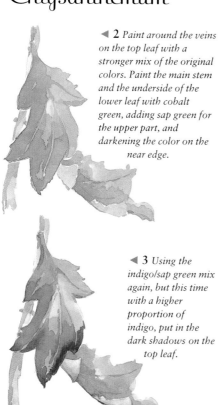

◀ **2** *Paint around the veins on the top leaf with a stronger mix of the original colors. Paint the main stem and the underside of the lower leaf with cobalt green, adding sap green for the upper part, and darkening the color on the near edge.*

▶ **2** *Paint in details around the veins with a mid-toned sap green, concentrating most of the color on the shaded side.*

Primula

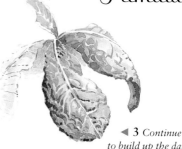

◀ **3** *Using the indigo/sap green mix again, but this time with a higher proportion of indigo, put in the dark shadows on the top leaf.*

◀ **3** *Continue to build up the dark shadows with an indigo/sap green mix, using the tip of the brush and making short, calligraphic strokes. To anchor the plant, suggest the soil beneath it with a wash of raw umber/burnt umber.*

Coleus

▼ **1** *Lay a variegated wash of Naples yellow/permanent rose over the leaf, leaving the edges white. As the paint dries, deepen with permanent rose at the top.*

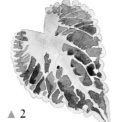

▲ **2** *When dry, paint the leaf edges with sap green and touches of green-gold, then paint the darker pattern in two tones of olive green, taking the paint carefully around the pink veins.*

▶ **3** *Darken the pink in places, using a mix of permanent rose and quinacridone gold. While still damp, paint in the spine and veins with a stronger permanent rose. Strengthen the green at the tips with a sap green/olive green mix.*

Rose

1 *Paint the leaves with varied washes of cadmium yellow and cobalt blue, using more yellow where they catch the light.*

▶ **2** *Paint around the veins on the nearer leaves with sap green, concentrating most color in the shaded areas. Add cobalt blue and paint the shadows and veins on the background leaves.*

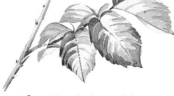

▲ **3** *Build up the forms of the nearer leaves with a sap green/olive green mix, varying the tones. Use the same mix for the stem, then add cobalt blue. Put in touches of detail on the background leaves before painting the thorns in brown madder.*

Tulip

1 *Mix lemon yellow and cobalt green and paint the top sides of the leaves and the stem, leaving white highlights. For the undersides of the leaves, add more cobalt green.*

▲ **2** *Deepen the shadows on the undersides with more cobalt green and a touch of sap green, leaving the central vein as a highlight. Soften the edges as you work. Paint around the main veins on the leaf tops using sap green and a bit of cobalt green.*

▲ **3** *Paint in the darkest details with indigo added to the two greens, again softening the edges where needed with a damp brush.*

CREDITS

EDITOR Steffanie Diamond Brown
ART EDITOR Sally Bond
ASSISTANT ART DIRECTOR Penny Cobb
COPY EDITOR Hazel Harrison
PROOFREADERS Anne Plume, Diana Craig
DESIGNER Penny Dawes
ILLUSTRATOR Adelene Fletcher
PICTURE RESEARCH Laurent Boubounelle, Frank Crawford

ART DIRECTOR Moira Clinch
PUBLISHER Piers Spence

Typeset in Great Britain by
CST Typesetters
Manufactured by Regent Publishing Services Ltd., Hong Kong
Printed by Leefung-Asco Printers, China